WILLEM DE KOONING

JOHN CHAMBERLAIN

de Kooning / *Chamberlain*

INFLUENCE AND TRANSFORMATION

ESSAY BY BERNICE ROSE

SEPTEMBER 21–OCTOBER 20, 2001

PACEWILDENSTEIN
32 EAST 57TH STREET NEW YORK CITY

Willem de Kooning and John Chamberlain: Displaced Realities

by Bernice Rose

"Art as action rests on the enormous assumption that the artist accepts as real only that which he is in the process of creating...." —Harold Rosenberg[1]

The works of Willem de Kooning and John Chamberlain face each other across several divides, among them that of time, one generation to the next, and, more particularly, of mode, painting versus sculpture. Nevertheless, Chamberlain would have no quarrel with Rosenberg's formulation, which took de Kooning's process-oriented technique as its model. Both de Kooning and Chamberlain agree in their reliance on chance operations and the language of fragmentation. For each the finished work is an intuitive sum of the displacements of function brought about by material operations on forms and colors, of solids played against open (or transparent) forms, and surface versus depth formations. The brushstrokes, which constitute the body of the work, and their disposition, which constitutes the subject, constantly shift, change speed and collide, defying any fixed reading.

Their art, in fact, epitomizes what had been construed, in particular, by another American critic, Clement Greenberg, as the desire of modernism from its inception to detach the elements of art from the representation of any reality outside itself and, ultimately, outside its own mechanisms of creation. What divides de Kooning and Chamberlain arises, paradoxically, out of the conceptual ground which connects them. Chamberlain's is a literal realization and transposition of the inherent sculpturality of de Kooning's painting—what Chamberlain seems to accept as its unrealized reality. The material divide between the two artists takes place along that long string of displacements of realities—and of the norms of representation—which characterizes the interpretation of modernist art, and modernity itself, as increasingly technology-driven and ultimately isolating. Chamberlain's work is a radical step in this history: the translation of de Kooning's inherently sculptural brushstroke from a soft material used for the creation of visual illusions and illusionary spaces into a hard, thin, and three-dimensional substance that could be considered as a support for those illusions. This translation changes not only the technology but also the sociology of the work. Although Chamberlain was less interested in the origins of his material than in the material itself, by using found materials that are familiar and, what is more, often evoke fond memories of tinkering with fragments of metal from crashed cars, he makes the technology of the work of art part of everyday life.

De Kooning had provided a primary model for the dictum, current in New York in the 1950s, that truth and therefore beauty lay in material operations. Through them, it might be possible to achieve a complete coincidence of gesture and meaning—of form and content (despite the contention that were such a thing possible, it would be abstract and empty of meaning). De Kooning's works had pushed this archetype of modernism to a newly critical level through a radical form of drawing with the brush, using various widths of a housepainter's brush, from a narrow lining brush to a broad one heavy with paint, collaging and overpainting in slashing theatrical strokes. Technique and address were everything, and de Kooning's brush, operated not just by his hand but by his whole body in motion, was the intermediary between drawing and painting, representation and abstraction, figuration and non-figuration, all operating as a densely material union, each realized in a luscious mix of colors worthy of the most ambitious Impressionist. De Kooning's operations were the model for Rosenberg's name for the New York School: Action Painting.

Jackson Pollock had already led the way with his brilliant drip paintings. He had combined drawing and painting, light and color, through linear movements—drawing with paint, performing with the whole of his body. There is a paradox in these paintings too: the factuality of his paint produced an optical illusion which fostered a sort of cosmic spatialization. Pollock had pushed his skeins of lines to the point at which, in the largest of these paintings, such as *Autumn Rhythm*, the line describes nothing but itself—no figures, not even the edges of planes. All description is subsumed to movement, to the tracking of line itself, to creating this extraordinary spatialization. And for a brief moment in these paintings, gesture and meaning were one. The felt presence of Pollock's body in the work is critical to our conviction about its authenticity as holder of meaning. But the moment was brief. Perhaps Pollock found some truth in the warnings that such a marriage would be dangerously abstract; perhaps the repetition of the same gesture could not hold the meaning he had hoped for; perhaps he felt that ultimately iat would be too difficult to maintain the presence of the subject—himself—in the picture as the line operated more and more mechanistically and pressed to become the agent of its own presence. In any case, he did return to figuration, that is to say, representation.

For de Kooning, as for Pollock (and all the New York School), scale—having an adequate arena in which to perform—was a critical factor. His paintings are as much the product of performance as Pollock's drip paintings. Whereas Pollock had erased genres, de Kooning's genres of choice in this process were figures and landscapes and combinations of them (and, very rarely, still lifes such as *Flowers, Mary's Table*, 1971 [plate 7]). All of these are combined in forms of scape—land-scape, table-scape, figure-scape. In the material realization of this interpenetrating mix of genres, de Kooning pushed painting to the limit of abstraction, while maintaining the sense of the operative body that is the work's true subject. The moment of finish occurred when the subject within the work and the operator on the outside came to some agreement about the meeting between form and content.

The salvation of de Kooning's subject depends upon his invention of a series of clichés of this grand brushstroke and his use of them over and over in an idiosyncratic manner. One cliché is a brushstroke that manages to present itself as shifting between abstraction and representation. The cliché has several faces, depending upon its placement and its attitude: if the artist wants it to be independent of delineation and concentrate on delineating itself, that cliché leans more toward painting. Or does de Kooning want us to concentrate on watching the line as it draws figures? The first formulation elicits former remnants or, more accurately, evocations, of body parts. The second reaches back to his works of the forties in which fragments of body parts were still represented by the drawing of outlines. In between, in both conception and in time, there are those purely automatic drawing strokes that are caricatures of themselves and the features they describe. Some of these strokes seem to follow the edges of contours—they resemble earlier contour lines—others cluster to suggest mass or volume. Each new constellation of gestures opens a new set of possibilities. Again and again, in new formulations, from one era to the next, from one painting to the next, we watch the recombination of the various modes of the brushstroke struggle to be free of anything but their own reality: we watch a stroke as it seeks to be a "figure," and then we watch its heroic denial even as it holds tenaciously to figuration, to some remnant of the idea of representing. As we read these forms, they evoke a memory of figuration—and of representation in a more general sense—as they reach toward abstraction. It is the struggle of the brushstroke to both remember figuration and yet to assert its independence from representation. The more dominant brushstrokes

already seem self-sufficient in this latter sense. Some are connectives, bridges between solidified spaces. With their changing voices, these gestures evoke rather than portray, however abstractly, connections to memories of visual realities—body, landscape, space, light, flesh, sky, place; landscape dislocated to the body and the body dislocated to landscape. In de Kooning's earlier work, the two had a more obviously mingled identity; one could read the process of displacement by the process of likeness, one thing equated to another through similarities in the movements of contour and shifts of color, and by the assimilation of shadow to line. Opposing formations are strewn in fragments, their relative scale distorted, creating a push-pull pattern in which relationships of part to whole are ripped asunder by inner necessity. In fact we feel the artist's body within these rushing color fragments, we feel it in the gesture, the stretch of arm propelling these strokes: heroic in their dash to freedom, but unable to detach from the body without losing their subject. All the space that de Kooning ever needed was located within that arm's reach.

These brushstrokes were something entirely new to art. They represent de Kooning's bid to move closer to the mythic goal of modernism, which Pollock had attained so briefly—the complete coincidence of meaning and gesture. In the late thirties and forties, de Kooning's drawings of women were savage caricatures that depended on Picasso's movable body parts and, in particular, on the distorted forms of the paintings of Dora Maar that Picasso made in the thirties.[2] In de Kooning's ripping and tearing, the sensuous experience of nature and the erotic desires of the body are connected; folded into one, they are nonetheless torn between soul and body and between those two poles of the erotic, desire and repulsion. In the fifties, de Kooning had taken his motifs out of the urban landscape. His cliché brushstrokes are a form of physical bravado that inscribed a kind of degraded urban pastoral, reorganizing the urban jungle (as it was called in movie lingo) as a ground of homeless representation (the phrase is Clement Greenberg's). This homeless ground was, in fact, the arena for the tawdry glamour of the decaying cityscape, personified in advertisements and glamour shots, particularly of Marilyn Monroe and other sex goddesses. De Kooning's savage brushstrokes (now definitively imitations of themselves), his collaging, were the ground strokes in which urban trash was lodged; they invaded and tore his figures and their grounds to fractured, twisted parts.

In such works as *Palisade*, 1957 (plate 2), and *Door to the River*, 1960 (plate 5), de Kooning's majestic color brushstrokes inscribe a different pastoral. Pushed to a new scale, they seem to be even more synthetic and sculptural: in their repeated layerings, clustering, constant changes in weight, mass, volume, transparency, and density, some strokes trail off, some collide, some break/brake off and some are stopped short by the constant movement of the crisscrossing gesture fracturing itself (and the surface) into fragments. The brushstroke in such works wants to be a sign that stands for itself, its edges describing only itself—its own movement. In these paintings, the broad muscular brushstrokes play off one another as raging elements of sea, sky, and land. The extraordinary and ever-changing multicolored light of eastern Long Island (and memories of the sea, sky, and land of Holland) combine to create a sort of homeless abstraction. The referent is to landscape, but landscape as seen while speeding along Montauk Highway, or to nature in a rage. These works do not originate in contemplative reflection of nature's beauty—although the fierce edge of that beauty, and of commercial paint color, is an inextricable part of the work. It is important to note that the titles follow the paintings. Illustrative references therefore reside only in the descriptive words, not in the paintings themselves. The titles may not even be de Kooning's. Why, then, accept them, except

for commerical reasons—to overcome the difficulty of selling pure abstraction. For instance, in *Door to the River*, it is as though we are suddenly forced to see a door, although there is no door. This strange relationship of title to work inscribes a real slippage, a displacement of the actual visuality of the paintings. The pragmatic inscription of some literal realism pins the paintings down in a way that tends to increase the difficulty with which the painting itself attempts to slip out of that dysfunctional relationship between the word and its meaning which has haunted the world since the Fall. Somehow, the literal imposition of the fallen word disrupts the fragile unity between gesture and meaning that de Kooning's performance of the painting means to inscribe.

In the seventies, the morphology of the work of art was subtly altered as the brushstroke again tried to persuade us that art is real life and in so doing fatally compromised its own independence. More than ever there was an urgency for the stroke to function as is its own body and, at the same time, as a displaced representation, a sum of fragments of representations which function as signs for bodies outside of the work, memories of bodies that used to be in the work, and the domain over which those bodies ruled. As such, the brushstroke is always in visual and metaphoric flux, its independence never clear-cut. Ambiguous, romantic in its attachments, at one moment it seems a complete form torn from a larger context, at the next, part of a larger whole.

With the revival of representation, the issue between the brushstroke as an object and the painting itself as an object, which had been raised to a newly critical level, was forced to retreat. De Kooning seemed torn between the wish to place meaning in the concrete perceptible substance of the art object, the desire to transfer all sense data to the erotic act of seeing, and his persistent attachment to the body—especially the female body. The seeing experience, always a function of scale, becomes more claustrophobic as the line resorts to detailing; it responds to smaller and tighter and more torturous descriptive movements of the brushstrokes. The movable parts of his figures squirm and taunt us with their absolutely comic grotesqueries. In earlier works, it was the artist's body moving in control with his strokes that gave pleasure to our bodies as well as to our sight. Now that he has again employed a surrogate subject, the eternal woman as temptress, the source of all pleasure and of creation itself, the subject has slipped into its dual role: it is both inside and outside the painting. As a result, it is the tactility of sight that dominates our pleasure—and our discomfort—in these complex and ultimately manic pastorals of the temptations of the flesh. These are now "real" women. No longer are they billboard goddesses or Picassos: they are genuine de Koonings.

De Kooning's brushstroke ought to be called a flexible or even malleable sign, in that it has the ability to absorb and project double, even triple—indeed multiple—and *violent* displacements of function. Playing a complex game of unity and displacement, de Kooning kept his options open as he manipulated his sign into a system that assumes multiple functional identities he could deploy to alter the sense of structure on which each individual work or group of works may depend. If, ultimately, de Kooning's performance in complex displacements of the brush-stroke did not result in permanent union, neither did it discourage his desire for it; rather it shifted the possibilities inherent in modernist painting to a new dimension: a blasted allegory of means, encompassing the edenic allegory of corruption and subsequent search for redemption through the means of painting—a (re)creation that lay at the heart of modernist painting.

The pastoral is an ideal ground for staging on such a scale of ambition—and the ground on which de Kooning and Chamberlain meet up as comrades. As a genre, the pastoral is a traditional subject of allegorical painting. Its convention, a landscape with figures, is bucolic, and it is historically understood as a kind of Garden of Eden encoded with the forecast of the Fall, an opposition between innocence and corrupt knowledge. As an occasion for erotic frolicking, the pastoral functioned as an ideal locus for displaced desire. Its tradition in modern art includes Degas' bathers and dancers, Cézanne's landscapes with bathers, Matisse's *Joie de vivre* and his two versions of *La Danse* and, a corrupt variant, Picasso's *Demoiselles d'Avignon*. The pastoral, moreover, had fueled Pollock's drive toward an art of pure abstraction. All these precedents, of course, had been de Kooning's point of departure in his voyage toward focusing on the brushstroke as the ideal instrumentation for modernism's ambitions. This voyage of the brushstroke reinforces the underlying allegorical potential inherent in modernism.

As a philosophical formulation, there are a number of variations on the pastoral. In one version, it is "less a genre than what William Empson calls a 'trick of thought,' the process of 'putting the complex into the simple,'"[3] which frees it from any prosaic association with landscape. Rather, the pastoral becomes "an inscription of a complex imagination of human relationships within the work of art, one which extends...to include the community of perception and feeling that exists between artist and...viewer."[4] In another interpretation, it is characterized as a struggle between simplicity and complexity: "The pastoral achieves significance by oppositions, by the set of contrasts, expressed or implied, which the values embodied in its world create with other ways of life. The most traditional is between the little world of natural simplicity and the great world of civilization, power, statecraft, ordered society, established codes of behavior, and artifice in general."[5]

De Kooning was certainly no simple shepherd of the brushstroke. Fragments in *collision* were his métier; each painting was proposed as an event. But he and Chamberlain nevertheless face each other across a divide in which each seems to belong to a different culture despite their common ground. The divide is one of demeanor as much as material or temporal displacement. It would be a mistake to believe that Chamberlain's sculpture is no more than a literal transcription of de Kooning's brushstroke: for transcription we must read transfiguration. Chamberlain's relationship to the brushstroke involves a real revolution in the nature of the art object—the complex appropriation of an aesthetic mode only to oppose it; tearing painting from the very things it could not afford to lose, especially illusion, and turning it into all the things it never would have thought of becoming, especially an everyday artifact. Chamberlain's unique contribution represents a total change of voice.

I noted with regard to de Kooning that the slippage between gesture and meaning had been actuated by the relationship of title to work: that is, by the awkward attempt to make the word somehow turn the painting into an illustration after the fact, to give it some recognizable descriptive context. Terry Eagleton has a particularly apt formulation for this postlapsarian problem: there "lies a nostalgia for the happy garden in which every object wore its own word in much the way that every flower flaunts its peculiar scent."[6] However, "to mourn the non-particularism of language is as misplaced as regretting that one cannot tune into the World Cup on a washing machine."[7]

The critical difference between Chamberlain and de Kooning is that Chamberlain would just as soon tune into the World Cup on a washing machine—he happens to find that the material of smashed cars makes more alluring and masculine tuners than washing machines. His pastoral is the accelerated version. It is not the pastoral in which there is a nostalgia for the happy garden, even in the form of grotesque caricature; he is not even interested in watching the countryside zip by while on the highway. He goes directly to the physical remains, the detritus, of civilization after the Fall in his try at visual coincidence of gesture with meaning. His is the ultimate ironic look at a comic book romance of industrial civilization in ruins. It is about pop culture on a collision course with civilization: a culture based on recycling the already accomplished demolition of established rules. The old nineteenth-century romance of a landscape of cultural fragments, which had been an escape from the industrial, is now displaced to an industrial model. Mirrors within mirrors, one cliché of the brushstroke transformed into another. Each displacement is a new artifice mocking an old one. After three movements of revolutionary reconfigurings in the making of objects—from Picasso to Dada and thence to Surrealism and Abstract Expressionism—the old dialogue between sculpture and painting at last comes home to the everyday practice of making sculpture.

Chamberlain had been to Black Mountain College, where the material world had been disassembled into a landscape of everyday artifacts. A culture of contingency ruled in each discipline. In poetry, theater, dance, music, the visual arts, the aesthetic of the fragment exploded to extend across the boundaries of all the arts—contemporary performance, which originated at Black Mountain, was "interdisciplinary." The term as it applies to aesthetic practice at Black Mountain does not refer to the use of mixed media to create an object that was neither a painting, nor a sculpture, nor a drawing, but to the breaking of boundaries between those disciplines, to the introduction of elements outside of them—and even external to art.

At Black Mountain, poetry and music, in particular, celebrated the everyday. Absorbing this attitude, Chamberlain, who was writing poetry, began to get the idea that making sculpture, too, was "daily life....everybody makes sculpture every day, whether in the way they wad up a newspaper or the way they throw the towel over the rack or the way they wad up the toilet paper....those little things, like blowing up a paper bag so that it pops—take it one little step further and do it in slow motion and explore what the resistance to the air in the paper is, and you make something."[8] Chamberlain's art was as much attached to performance (action) as was de Kooning's painting. The basis of much that went on at Black Mountain was the interpretation of Pollock's technique of painting as a performance, and to some extent de Kooning's painting as an action performed on his material. Performance is the one mode in which the body (the subject) and the gesture are in lockstep with form and content—and that coincidence of meaning and gesture lasts for only the flicker of an eye.

Displacing art from a sublime gesture in paint to an everyday operation on base material mediated via performance and linked to a new vernacular poetry and music sent Chamberlain off in an entirely different direction. The gestural brushstroke that had begun as a dialogue with the irreducible uniqueness of Action Painting, and ended up as a cliché of itself, had become an everyday reality. Rauschenberg made it clear that painting accidents could be repeated, that spontaneity was an artifice. He relocated the inherent three-dimensionality of de Kooning's painting,

including the bodily gesture that operated outside the work, into works in three dimensions made of found objects. He then used them in performances, not simply as props but as actors. Rauschenberg's early sculptures were the leftovers of performance.

Chamberlain, who had been making sculpture in the mode of David Smith, seems to have begun to conceive of the material outcome of gesture as a form of real imitation (in the parlance of Duchamp), a three-dimensional ready-made—or assisted ready-made—in metal, complete with color. The painted brushstroke was no longer some unique transcendent act; it too was made of base material and was no longer a privileged, unique property. It was even less so when embodied gestures could be picked up in the junkyard, where, having been made by the everyday accidents of life, they were cast off. But Chamberlain, who was impressed by de Kooning's "voluminous paintings of 1955 and 1956, such as *Gotham News...*,"[9] was above all interested in the speed with which painting could be made. According to Donald Judd, he didn't like the "methodical labor of sculpture, nor its effect....using crushed and colored metal was a way to have something in the beginning and avoid conspicuous tinkering."[10]

Fragments and even the syntax of Chamberlain's early poetry, which later ruled his titles, forecast the operative logic of his high-speed object-making. For instance, *Archaic Stooge*, 1991, which vulgarly puns its way into renewed sense—narrates how he put poetry together from the start with words he found, isolated from context, and opposed to one another in a displacement between logical syntax and meaning. Their puns parallel the displaced syntax of found materials in the sculpture; they are a satire of illustrative titling in that they are not illustrative. They are mainly accidental and automatic extraneous thoughts on the realities attached as supplementary information. In effect, his titles are a parody of the disassociative syntax that had been a part of modernism from Cubism on: the displacement and reassembly of fragments into a new whole and (beginning with collage) the incorporation of everyday materials as a sign for reality, along with the real color inherent to that material. The real imitation brush-strokes, now the module of Chamberlain's work, were found in street materials, altered and fitted together by juxtaposition, until the parts worked as a whole (structurally as well as visually). Spontaneity was transferred to the "find" and to the fit. The individual components were then welded, initially using iron rods as a support—a good low-tech backyard-industry method.

Neither Chamberlain's preferred found material nor the concept of using found material was new to art, although the source was—and especially its scale. Chamberlain's innovation was to use parts of a manufactured industrial form as ready-made fragments of sculptural forms. He chose automotive parts, with their shiny industrial colors like a wonderful skin and their rusted natural textures. Although many of these remains of vehicles could be read as having a life history, whether of violent accident or—as with many of the materials of pop culture—as outdated and discarded, and then crushed for disposal, ripping their remains from context, Chamberlain read their materials as abstract, their connections as physical. What he saw was soft sheet metal, smashed up and deflated, fragmented, crunched and crimped, as though by a sudden collision; not unlike that smashed paper bag, each piece of metal was an event. What was distinct to Chamberlain's work was that the material was used like an ordinary art material. It was not just that it was colored, but that it had the same use-value as paint—or as plaster or marble: though found,

it had to be assembled and in some cases shaped. To be art, in other words, it had to go through artistic operations, achieve an artistic identity by some sort of manipulation. Never mind that the operations were carried out by relatively primitive industrial techniques. Chamberlain chose those fragments of industrial culture which worked like the gestures and volumes of painting, specifically de Kooning's painting. But there were no more illusions—only events (although the possibility remains that the events were the real illusions) in these crumpled fragments. Instead of memories of bodies and lines moving in command to the flat surface and the four sides of a canvas, Chamberlain constructed his sculpture out of self-sufficient forms, lines of direction that did not bend in order to describe the edges of volumes, but bent and moved in real space. In de Kooning's paintings, Chamberlain saw spaces that seemed as volumetric and solid as objects. In Chamberlain's sculptures—for instance, *Zaar*, 1959 (plate 1), these painted spaces between became real objects standing in space. The tendency of painting, which depends upon drawing, to interchange figure and ground was realized by Chamberlain as a sculptural opportunity: an abstract reality, personified.

Often movement is drawn in a spiral and folds the sculpture in on itself. The tendency to be prolix is a conspicuous feature of Chamberlain's sculpture. It is part of its sociability. In such works as *Swannanoa/Swannanoa II*, 1957/74 (plate 3), the narrow color-strips of metal that hold the two wings together are as explicitly linear in their movement as any drawn or painted line. According to Donald Judd, "the structures and shapes are those of the movement of things. The surfaces depict this movement. The imagery is either this alone or is organic as well."[11] In de Kooning's painting, Chamberlain had seen color that engaged volume because it was so physical and real. In his sculpture, it was even more real. It was neither extrinsic nor intrinsic—it was simply there; and its facture—its basic expressive accidents of material presence—was not induced but, to Chamberlain, authentic and real. And each trace encoded speed—and it would be false to deny that its tenor is the romance of the road, of tough love, of lowness. We all know by now that *Easy Rider* comes to a bad end; Chamberlain's speedy junk salvaged for the high culture which initially produced it is an antecedent of Mad Max, the hero who stands alone amidst the detritus of civilization, searching for salvation in its fragments.

But Chamberlain did not take his fragments at face value: he roughed up his found materials and tarted up the color to remove the traces of prior identities. He found that by using a junkyard crushing machine he could bend and crimp the material, get thin flat pieces or broader, heavier ones, make fat tubular, shiny pieces and cut them off, and use broader planar sheets and bend them. The tarting up began when he found that before compacting the raw material, and without compromising the structure, he could supplement the existing color with inflections of brightly colored shiny enamel paint. In fact, the extra layer added to the optical complexity and sparkle of a piece. Surprisingly, all of this is more elegant, more polished, and more finished than any of de Kooning's deliberately rude and crude drawing.

Chamberlain's paint additions are a form of paint-as-free-will—wholly abstract and concrete in its operations—a way to deal with Pollock's painting and with sexuality, in one. Chamberlain's generation tended to regard the aluminum house paint Pollock used as both physically specific and optical at the same time. The shiny bare metal in such sculptures as *Balzanian*, 1988 (plate 16), is a clear reference to Pollock's optically active aluminum paint, but here it remains true to its material—a basic or neutral element, both structure and color.

Misusing—or rather employing the myth of—Pollock's technique, as well as his and de Kooning's displacement of gesture into an abstract outcome, Chamberlain pours, splashes, drips, and puddles paint, defying the strictures of form equals content. Often, he lets the paints physically mix themselves into one another. And sometimes he adds airbrush to the mix, another of those backyard low-tech industrial techniques, using it to make areas of glitzy color, as in *Argentine Brilliantine*, 1989 (plate 9). In works such as *Miss Lucy Pink*, he exposes yet another aspect of this random color—its ribald female sexuality. Chamberlain's painting, for it is that, is a form of joyously flashy, decorative dress-up that outs what is often called the other. There is a vital female aspect to Chamberlain's work, opposed to the masculinity of his tough-guy machine-made structures. The sexual angst of de Kooning is gone, replaced by a blatant erotic charge of sheer enjoyment, which is played up to by such jokey feminized titles as *Miss Lucy Pink*; in the masculine gender, *Half Cockney*, 1988 (plate 20), fills the bill as a sexy and hokey verbal/visual pun.

Yet Chamberlain gets as close as anyone to that mystical moment when gesture and meaning are totally coincidental. He may act as though he believes that moment doesn't exist or is no longer important, or as though he is not concerned anymore. Laughing, he nails gesture down, saying take that and take that, while celebrating the non-particularism of language. He just goes on doing one thing after another, inspired by Pollock and by de Kooning. And, slyly, he reaches out to an automobile fender to tune himself into that magic moment when reality becomes reality and can be recognized as truth.

NOTES

1 Harold Rosenberg, "The American Action Painters," *Art News*, 51 (December 1952), p. 22.

2 De Kooning's transpositions of Picasso's Dora Maar paintings contain within them the possibilities for Picasso, in his last works, to then reinterpret his own work according to de Kooning's brushstrokes. Their primary interface is the moving of body parts and the role of the brushstroke. Picasso adapts de Kooning's integration of color to line as a structural unit. However, Picasso's line never goes as far from description as de Kooning's, although in his last works one can enjoy line for itself as sensual experience. De Kooning's more independent brushstroke occupies several more dimensions than Picasso's.

3 William Empson, *Some Versions of the Pastoral* (rev. ed., New York: New Directions, 1974), p. 23, quoted in Thomas Crow, "Versions of the Pastoral in Some Recent American Art," in *The BiNATIONAL: American Art of the Late 80s* (Boston: The Institute of Contemporary Art and Museum of Fine Arts, Boston, 1988), p. 26.

4 Empson, quoted in Crow, "Versions of the Pastoral," p. 115.

5 David M. Halperin, *Before Pastoral: Theocritus and the Ancient Art of Bucolic Poetry* (New Haven and London: Yale University Press, 1983), pp. 70-71, quoted in Crow, "Versions of the Pastoral," p. 27.

6 Terry Eagleton, "Art After Auschwitz," in *The Ideology of the Aesthetic* (Oxford: Basil Blackwell, 1990). p. 342.

7 Ibid.

8 John Chamberlain, quoted in Julie Sylvester, "Conversations with John Chamberlain," in R.H Fuchs et al., *John Chamberlain: Current Works and Fond Memories, Sculptures and Photographs 1967-1995*, exh. cat. (Amsterdam: Stedelijk Museum; Wolfsburg: Kunstmuseum Wolfsburg, 1996), p. 40.

9 Donald Judd, "Selected Writings on the Work of John Chamberlain," in *John Chamberlain: Current Works and Fond Memories*, p. 65.

10 Ibid.

11 Ibid.

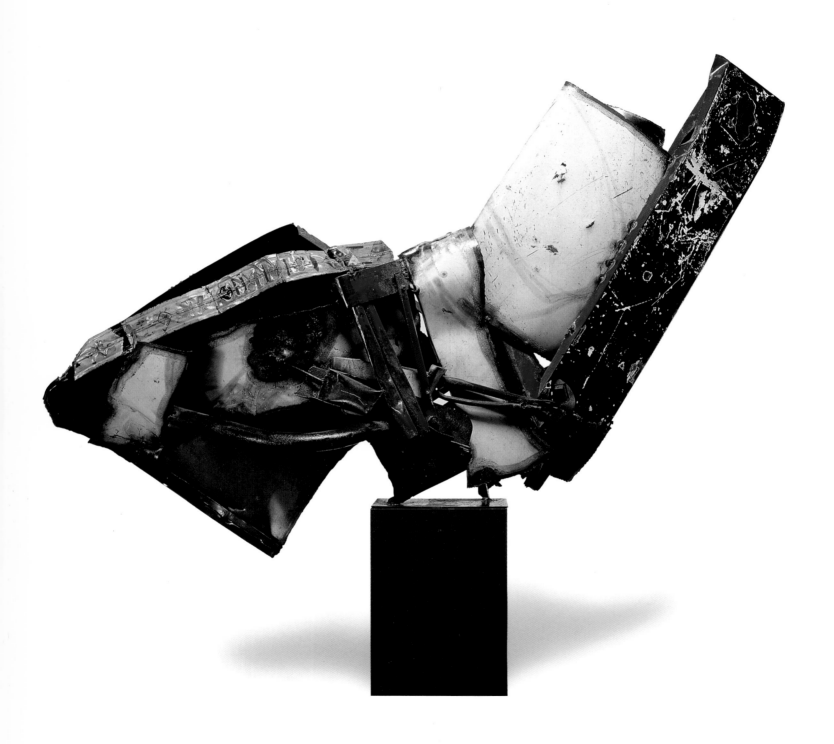

1. **ZAAR** 1959 welded steel, painted, 51¼ x 68⅜ x 19⅝"

In the early sculptures I used anything made of steel that had color in it. There were metal benches, metal signs, sand pails, lunch boxes, stuff like that. For instance, there is a sculpture, Zaar, that was titled after a permanent wave. It was made from a green metal bench with a red stripe on the side of the seat.

JOHN CHAMBERLAIN

I wasn't interested in the car parts per se, I was interested in either the color or the shape or the amount. I didn't want engine parts, I didn't want wheels, upholstery, glass, oil, tires, rubber, lining, what somebody'd left in the car when they dumped it, dashboards, steering wheels, shafts, rear ends, muffler systems, transmission, fly wheels, none of that. Just the sheet metal. It already had a coat of paint on it. And some of it was formed. You choose the material when that's the material you want to use, and then you develop your processes so that when you put things together it gives you a sense of satisfaction.

JOHN CHAMBERLAIN

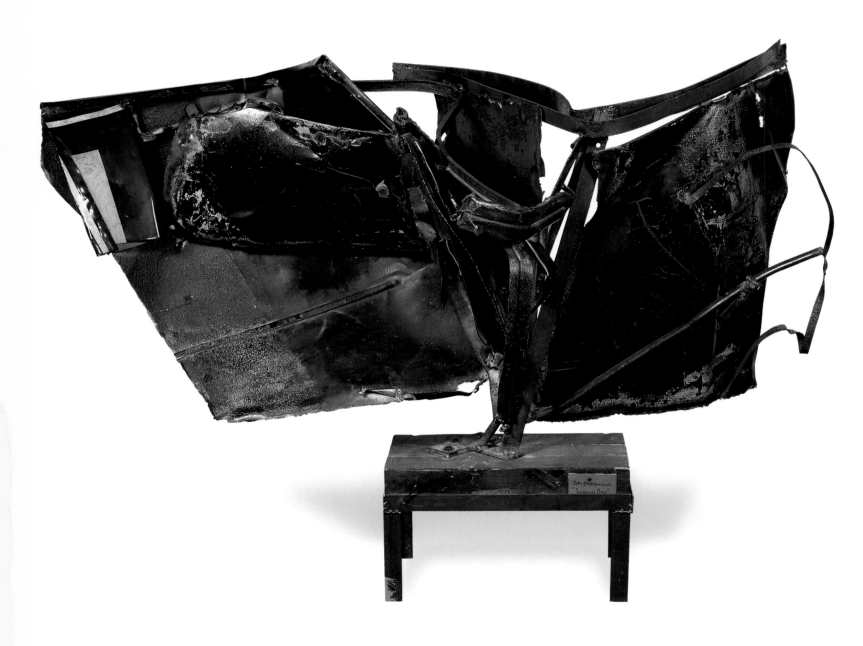

3. **SWANNANOA / SWANNANOA II** 1959/74 painted and chromium-plated steel, 45½ x 66 x 25½"

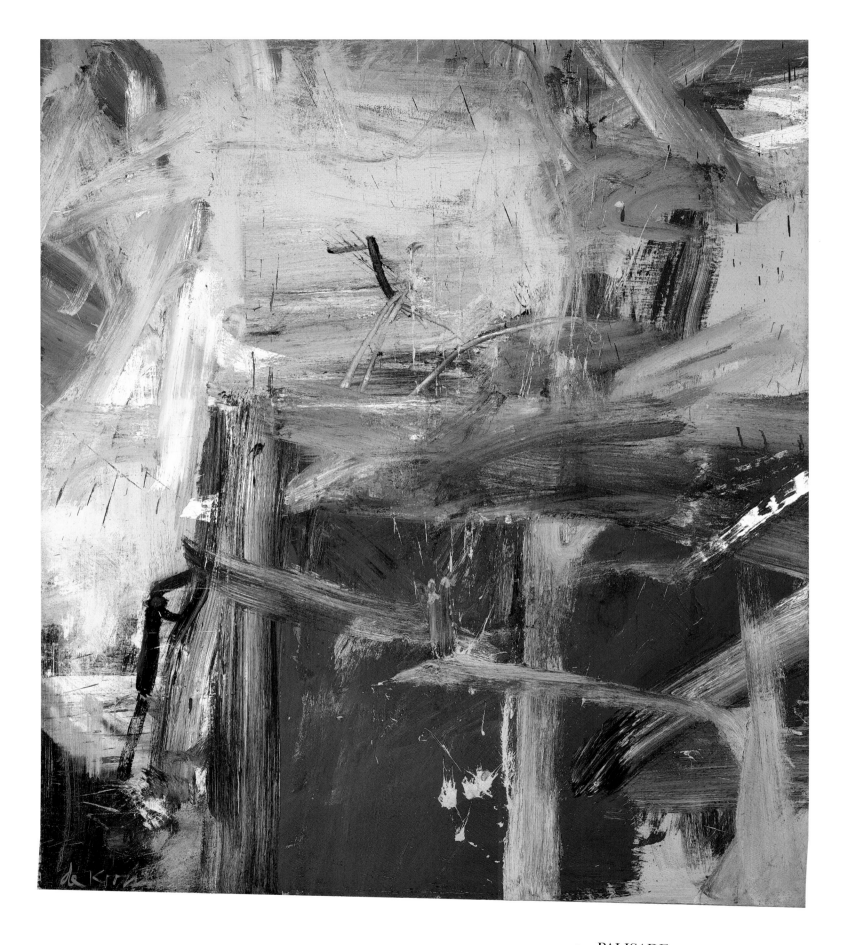

2. **PALISADE** 1957 oil on canvas, 79 x 69"

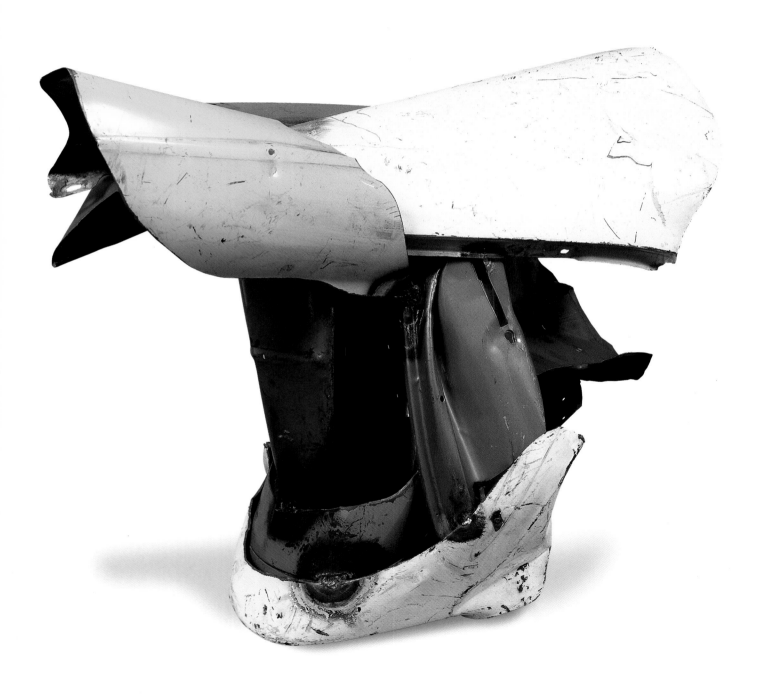

4. **UNTITLED** 1963 painted and chromium-plated steel, 31 x 37 ½ x 28"

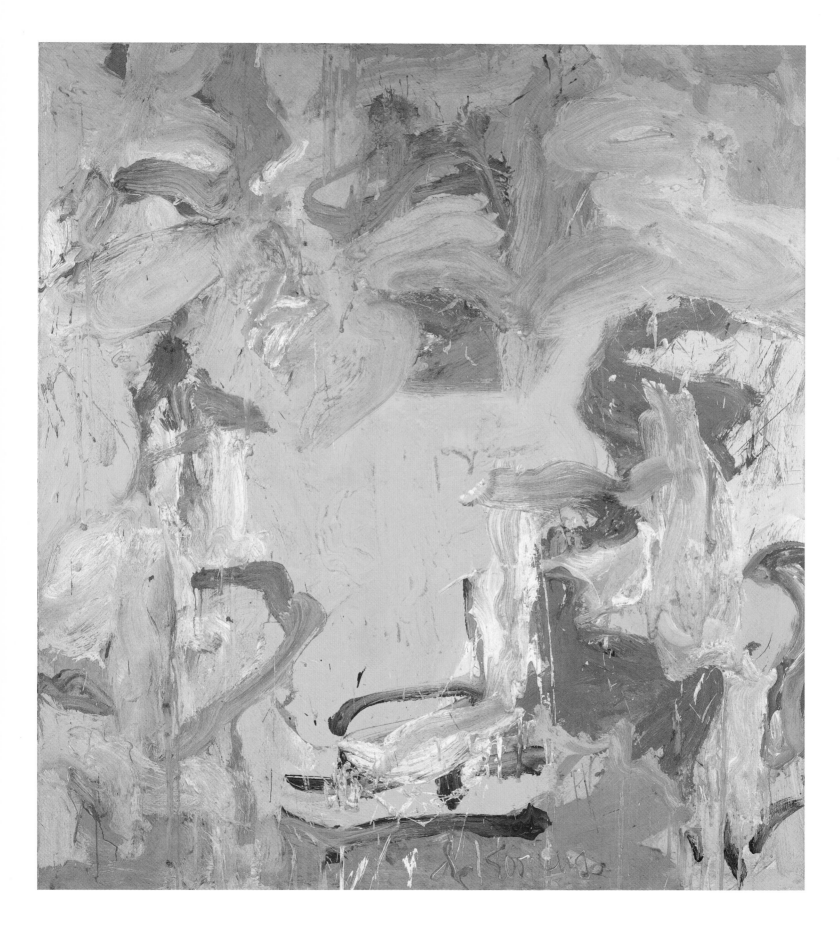

7. **FLOWERS, MARY'S TABLE** 1971 *oil on canvas, 80 x 70"*

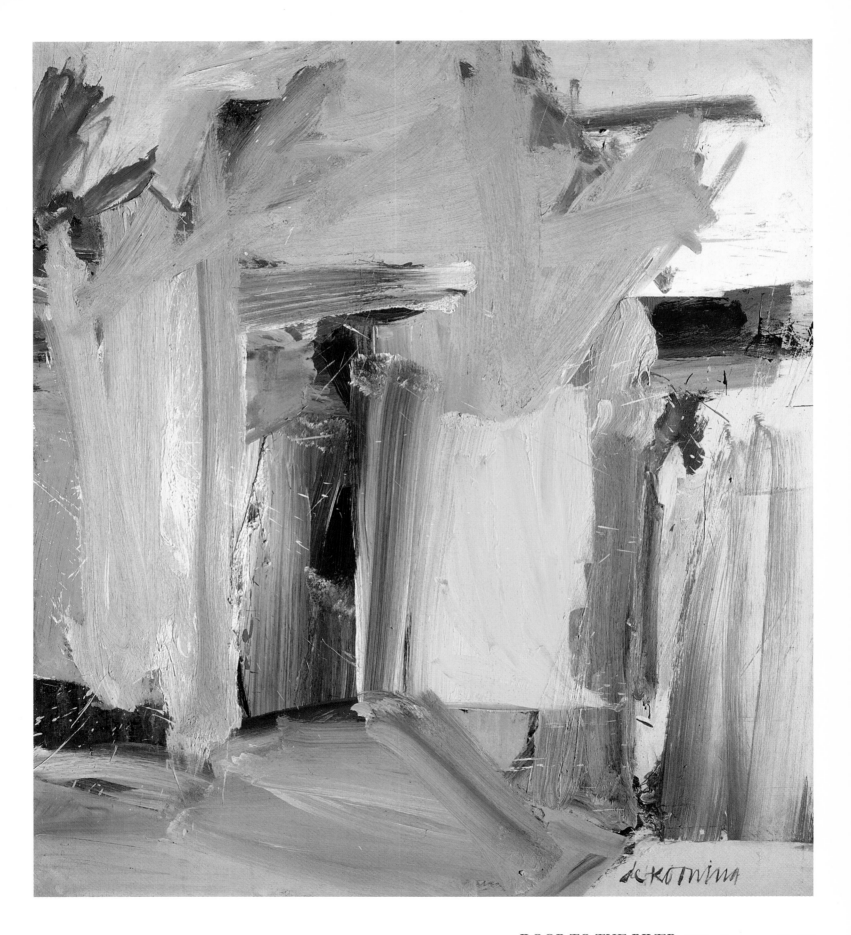

5. **DOOR TO THE RIVER** 1960 oil on canvas, 80 x 70"

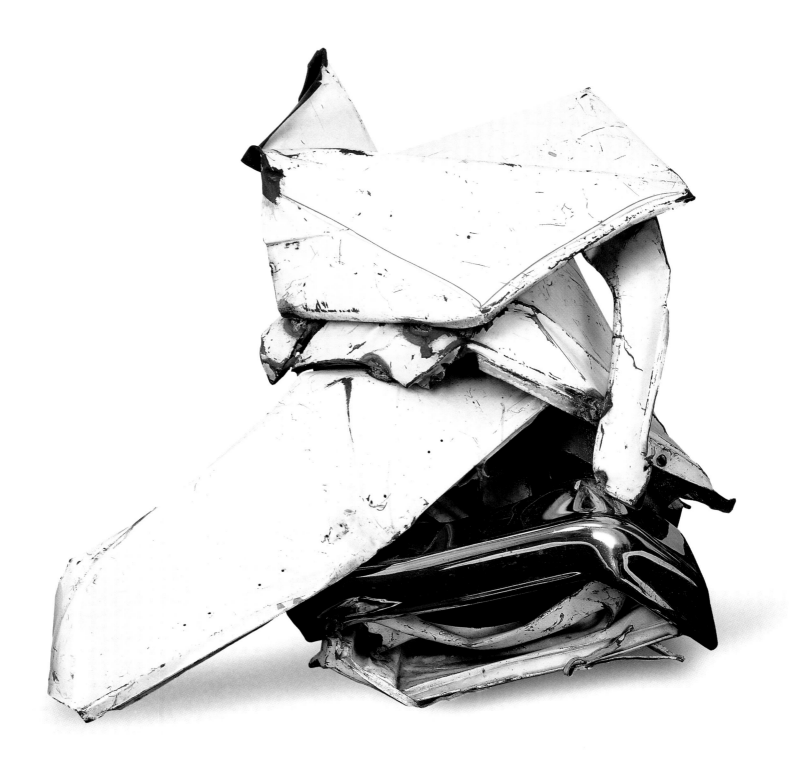

6. **HIDDEN FACE** 1962 painted and chromium-plated steel, 41 x 50 x 33½"

I think that I selected those materials at that time for that particular piece because they were pink, all different shades of pink, very close, and not because they came form an automobile. Miss Lucy Pink has a sort of front and a back. I look at the piece every now and then and sometimes it reminds me of somebody who's putting on a good front, but you take a look around the back and her ass is hanging out.

<div align="right">

JOHN CHAMBERLAIN

</div>

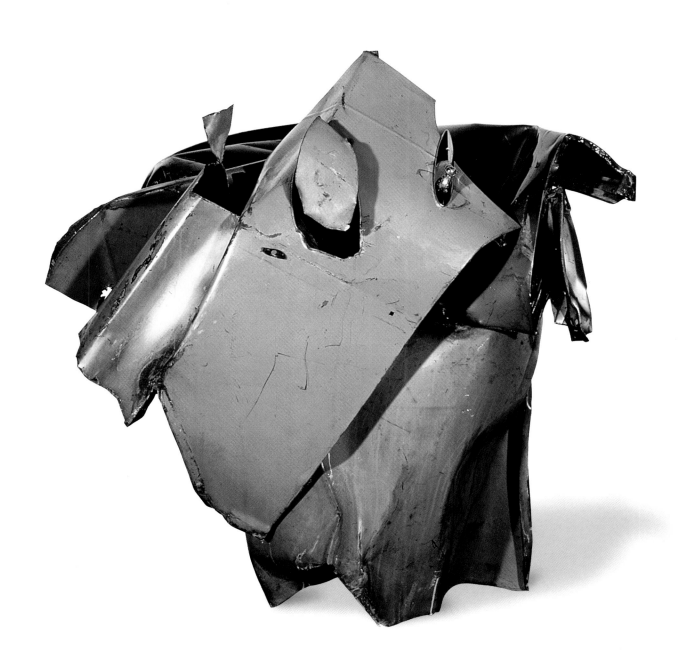

8. **MISS LUCY PINK** 1963 painted and chromium-plated steel, 47 x 42 x 39"

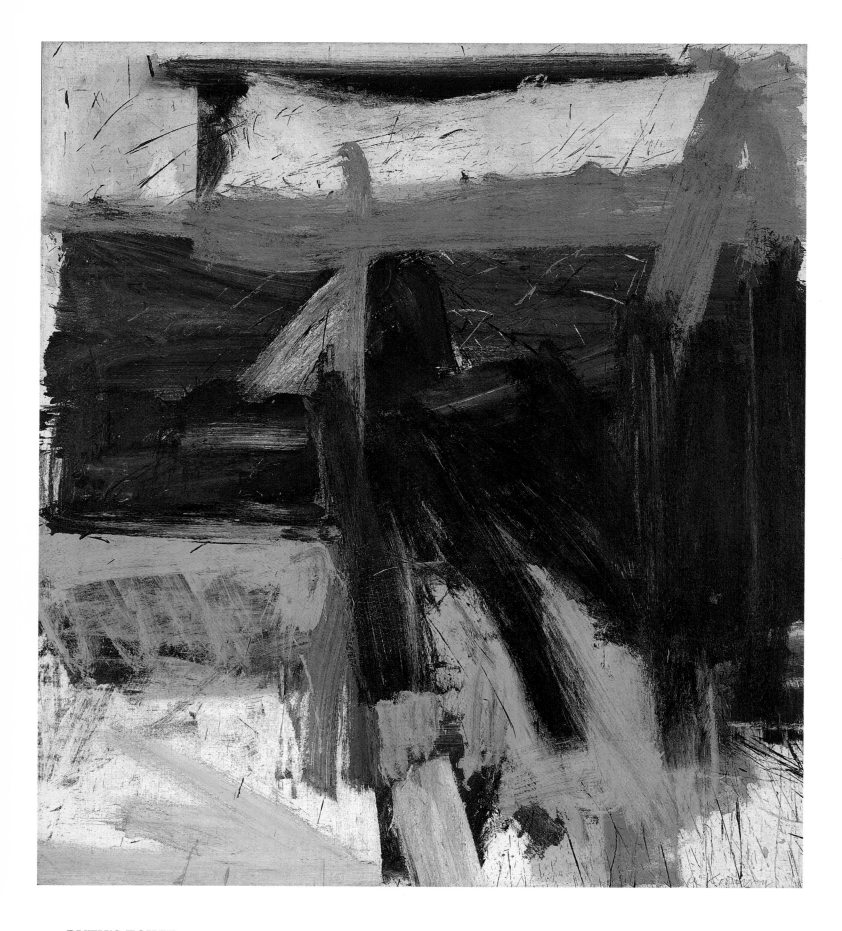

10. **RUTH'S ZOWIE** 1957 oil on canvas, 80¼ x 70⅛"

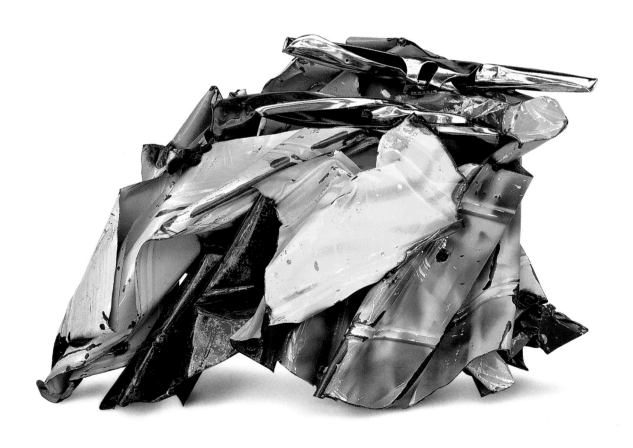

9. **ARGENTINE BRILLIANTINE** 1989 painted and chromium-plated steel, 34 x 49¾ x 41"

No object can be tied down to any sort of reality; a stone may be part of a wall, a piece of a sculpture, a lethal weapon, a pebble on a beach, or anything else you like, just as this file in my hand can be metamorphosed into a shoe-horn or a spoon, according to the way in which I use it....So when you ask me whether a particular form in one of my paintings depicts a woman's head, a fish, a vase, a bird, or all four at once, I can't give you a categorical answer, for his "metamorphic" confusion is fundamental to what I am out to express....And then I occasionally introduce forms which have no literal meaning whatsoever. Sometimes these are accidents, which happen to suit my purpose, sometimes "rhymes" which echo other forms, and sometimes rhythmical motifs which help to integrate a composition and give it movement....Objects don't exist for me except insofar as a rapport exists between them and myself.

WILLEM DE KOONING

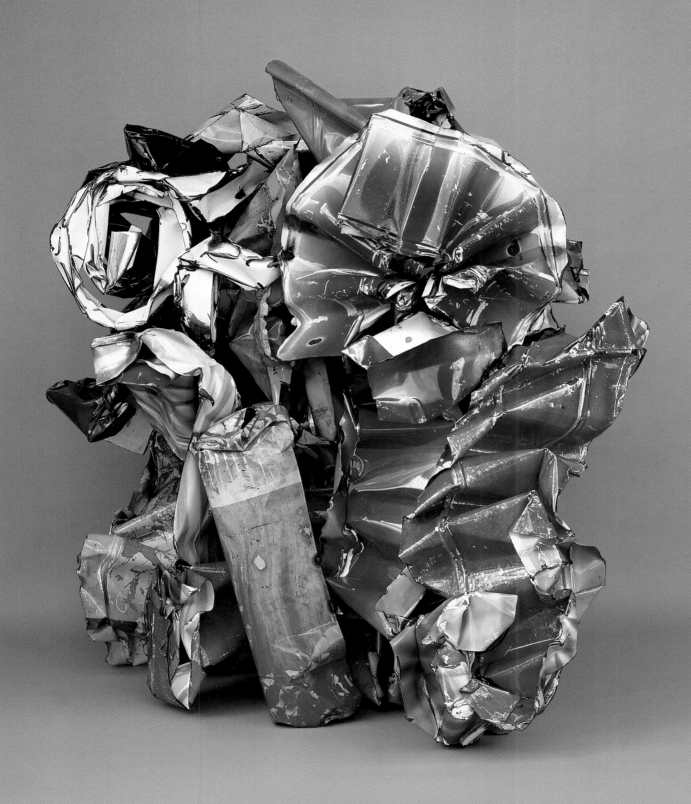

12. HAUTE CINQ 1990 painted steel, 76⅛ x 75⅛ x 64⅛"

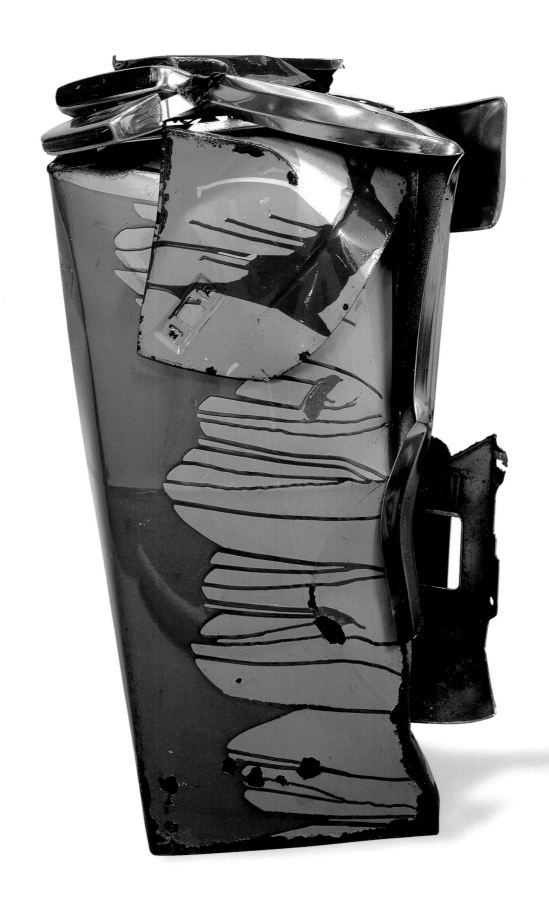

11. **DIFFERENT HENRY** 1974 painted and chromium-plated steel, 48 x 26½ x 18"

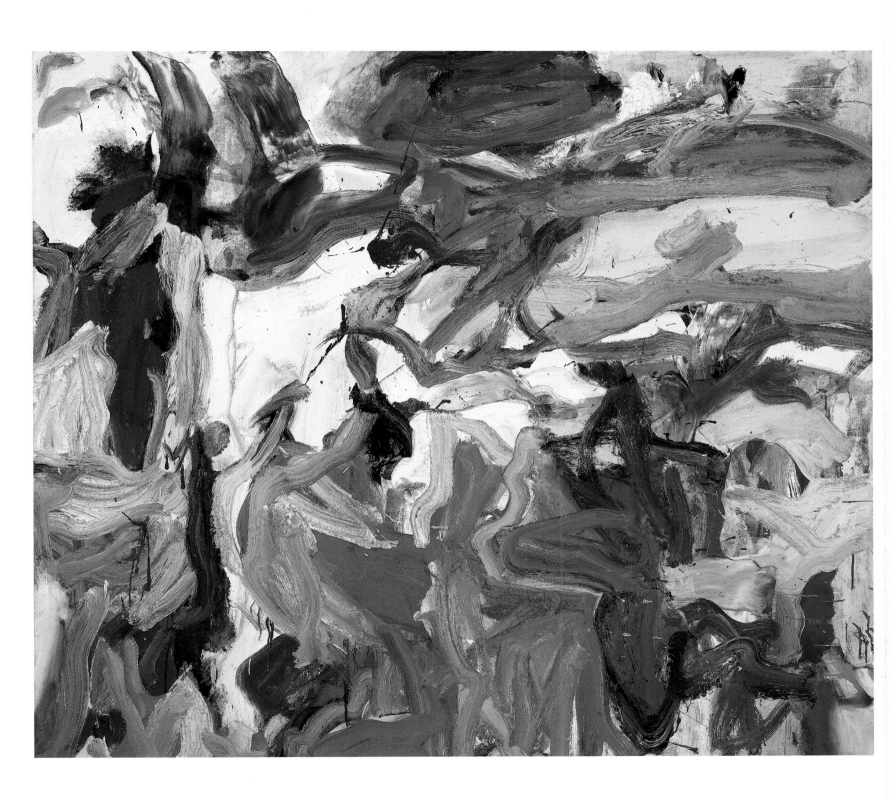

13. **UNTITLED XIV** 1976 oil on canvas, 70 x 80"

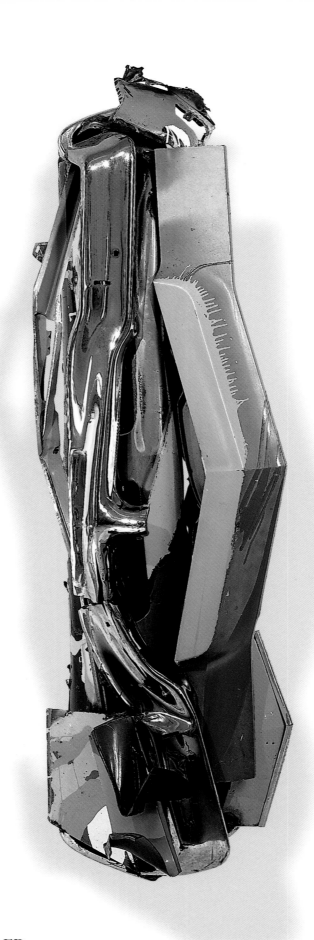

14. **UNTITLED** 1977 painted and chromium-plated steel, 82 x 23 x 20"

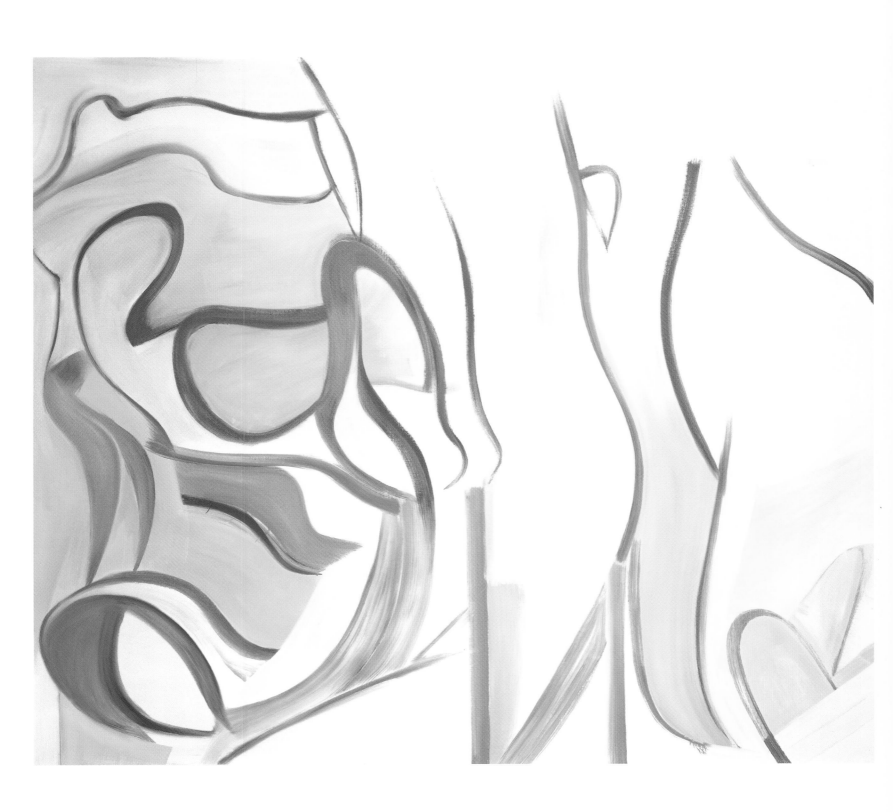

15. **UNTITLED VIII** 1985 oil on canvas, 77 x 88"

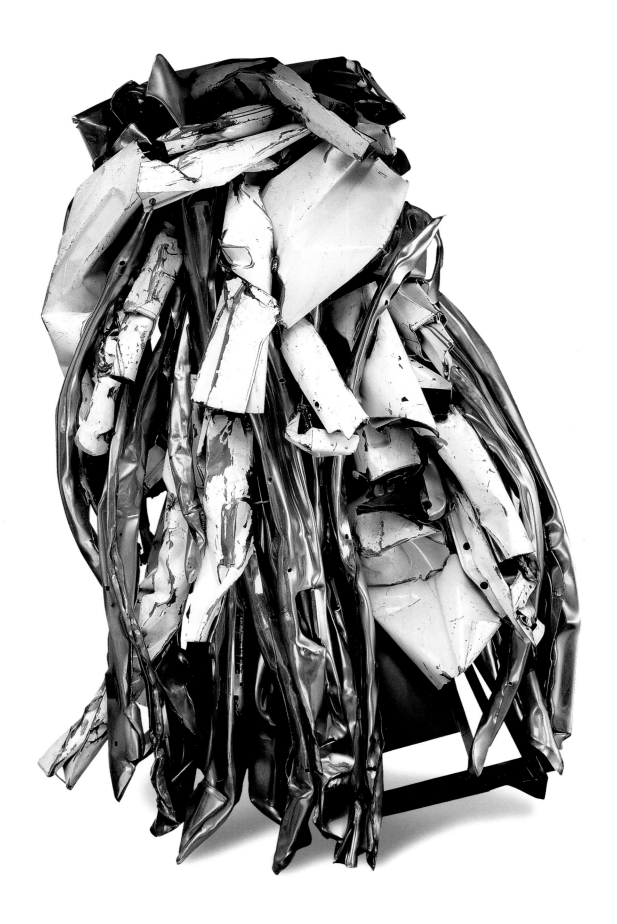

16. **BALZANIAN** 1988 painted and chromium-plated steel, 89½ x 62 x 48½"

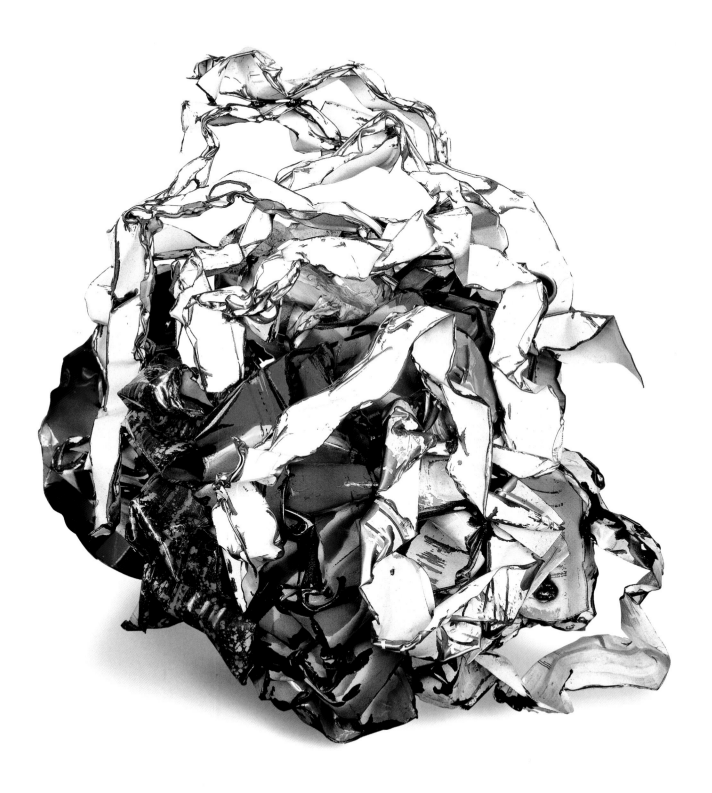

19. **SAVOY KOI** 1991 painted steel, 54½ x 60 x 48"

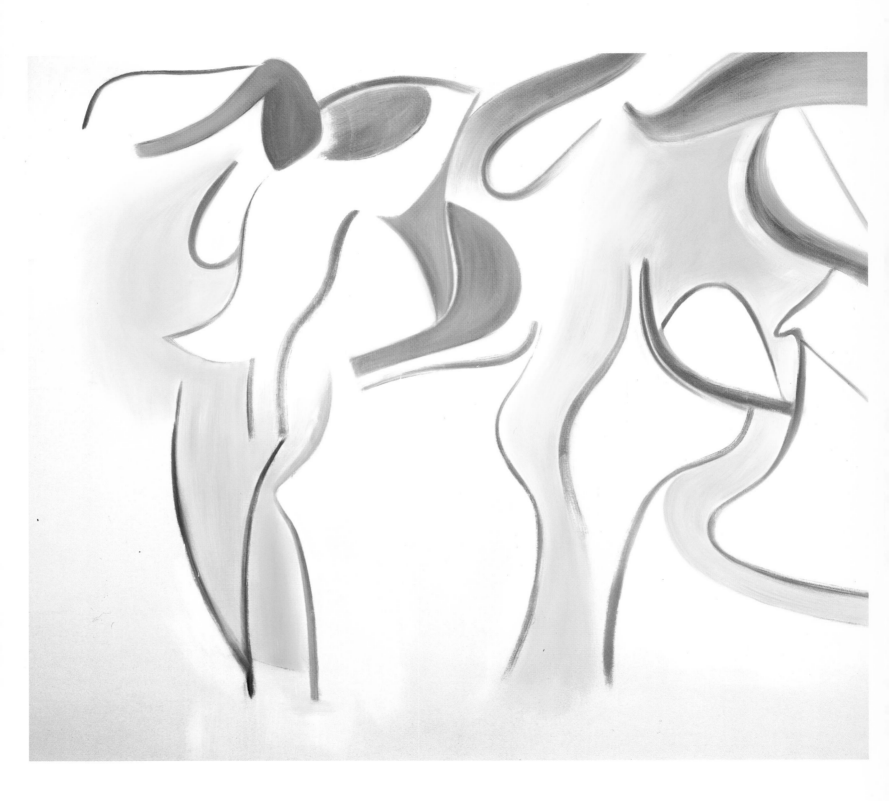

17. **UNTITLED** 1985 oil on canvas, 77 x 88"

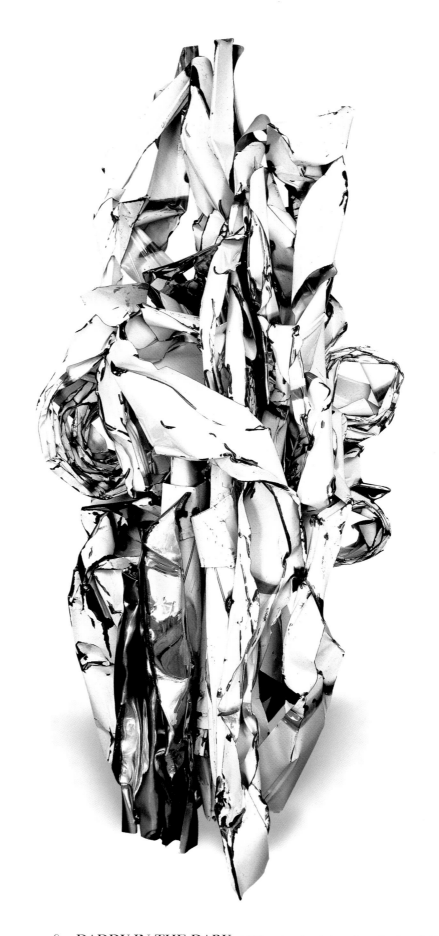

18. **DADDY IN THE DARK** 1988 painted and chromium-plated steel, 112¼ x 65 x 51½"

You use [colors] it in a graffiti manner, or as though you were writing a foreign language that you didn't really know, so you write as if it were a penmanship exercise rather than communication. That's the way I paint. My graffiti, or what's referred to as graffiti in my work, expresses my thoughts about how painting comes about.

JOHN CHAMBERLAIN

When I came [to the Springs] I made the color of sand...As if I picked up sand and mixed it. And the grey-green grass, and the beach grass....When the light hits the ocean there is kind of a grey light on the water....I had three pots of different lights....Indescribable tones, almost. I started working with them and insisted that they would give me the kind of light I wanted. One was lighting up the grass. That became that kind of green. One was lighting up the water. That became that grey. Then I got a few more colors, because someone might be there, or a rowboat, or something happening. I did very well with that. I got into painting the atmosphere I wanted to be in. It was like the reflection of light. I reflected upon the reflections on the water, like fishermen do.

WILLEM DE KOONING

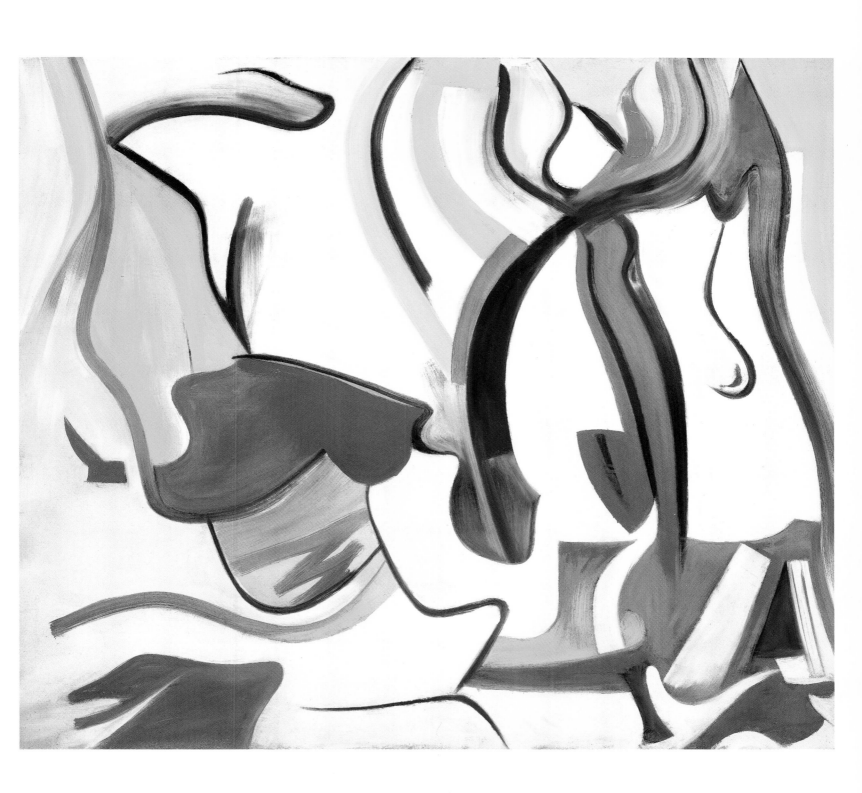

21. **UNTITLED VII** 1985 oil on canvas, 70 x 80"

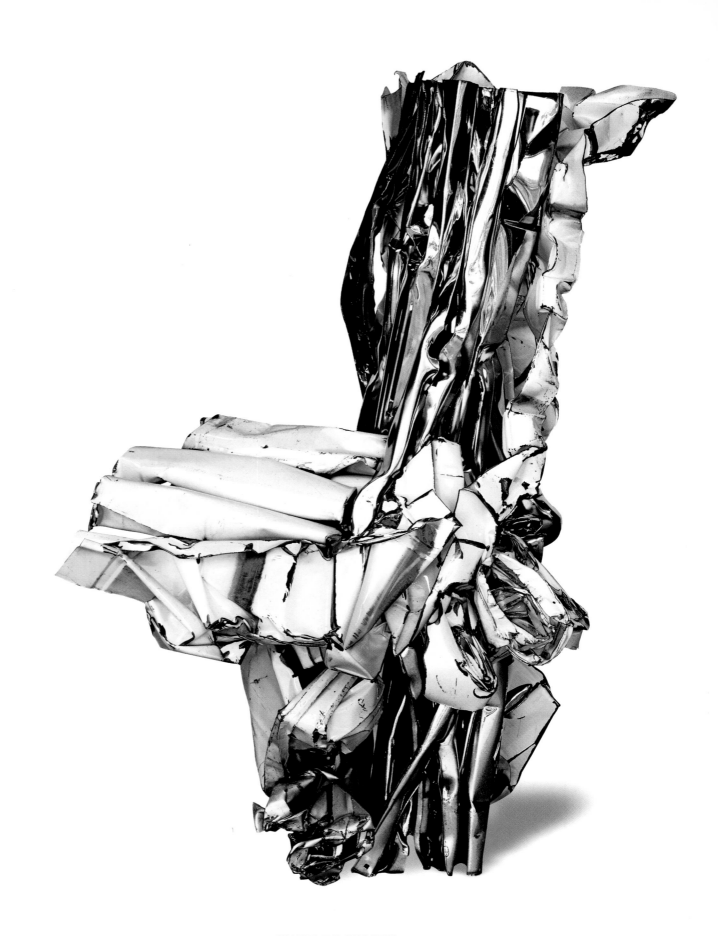

20. **HALF COCKNEY** 1988 painted and chromium-plated steel, 82¼ x 60 x 43"

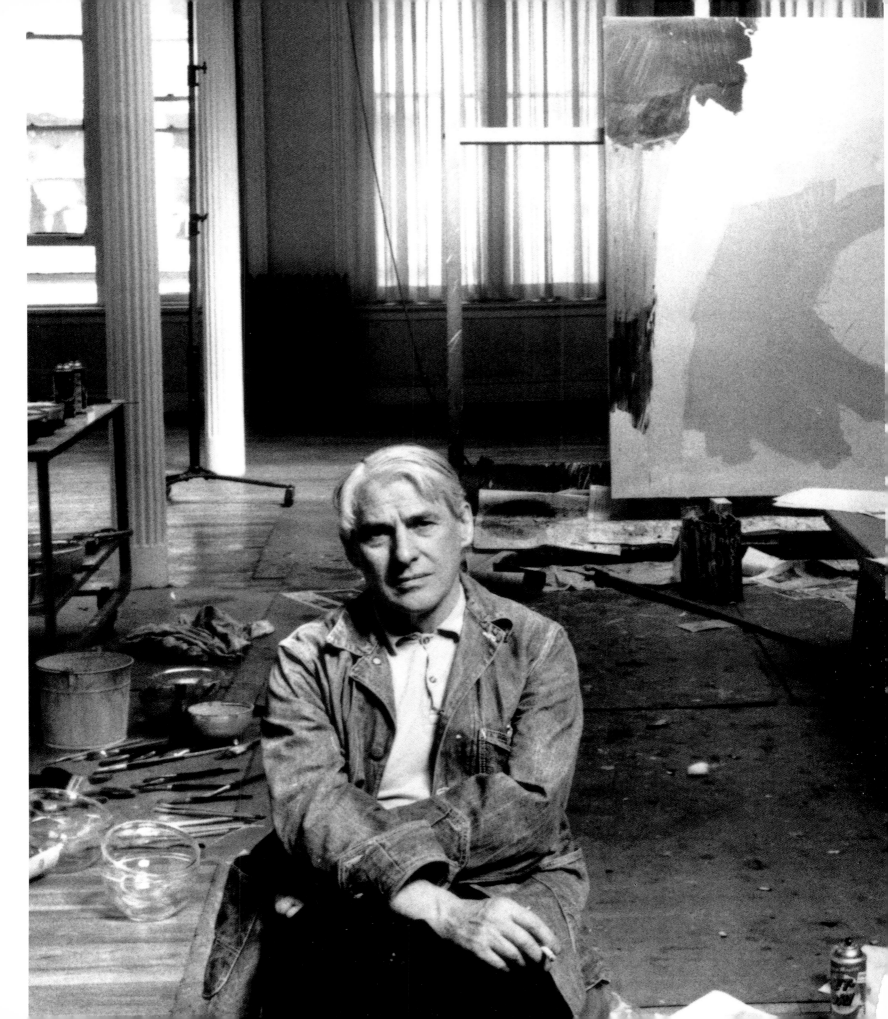

1	John Chamberlain	**ZAAR** 1959 The Patsy R. and Raymond D. Nasher Collection, Dallas, Texas
2	Willem de Kooning	**PALISADE** 1957 Private Collection
3	John Chamberlain	**SWANNANOA/SWANNANOA II** 1959/74 Dia Center for the Arts, New York
4	John Chamberlain	**UNTITLED** 1963 Collection Whitney Museum of American Art Purchase, with funds from the Howard and Jean Lipman Foundation, Inc. and gift
5	Willem de Kooning	**DOOR TO THE RIVER** 1960 Collection Whitney Museum of American Art Purchase, with funds from the Friends of the Whitney Museum of American Art
6	John Chamberlain	**HIDDEN FACE** 1962 Dia Center for the Arts, New York
7	Willem de Kooning	**FLOWERS, MARY'S TABLE** 1971
8	John Chamberlain	**MISS LUCY PINK** 1963 Private Collection
9	John Chamberlain	**ARGENTINE BRILLIANTINE** 1989 Private Collection
10	Willem de Kooning	**RUTH'S ZOWIE** 1957 Private Collection
11	John Chamberlain	**DIFFERENT HENRY** 1974 Private Collection
12	John Chamberlain	**HAUTE CINQ** 1990
13	Willem de Kooning	**UNTITLED XIV** 1976 Private Collection, San Francisco
14	John Chamberlain	**UNTITLED** 1977
15	Willem de Kooning	**UNTITLED VIII** 1985
16	John Chamberlain	**BALZANIAN** 1988 Private Collection
17	Willem de Kooning	**UNTITLED** 1985 Hirshhorn Museum and Sculpture Garden, Smithsonian Institution Holenia Purchase Fund, In Memory of Joseph H. Hirshhorn, 1991
18	John Chamberlain	**DADDY IN THE DARK** 1988 Private Collection
19	John Chamberlain	**SAVOY KOI** 1991
20	John Chamberlain	**HALF COCKNEY** 1988 Private Collection
21	Willem de Kooning	**UNTITLED VII** 1985 The Museum of Modern Art, New York Purchase and gift of Milly and Arnold Glimcher, 1991

SELECTED CHRONOLOGY

1904	Born in Rotterdam, The Netherlands.
1916	Left grammar school; began apprenticeship with the commercial art and decorating firm of Jan and Jaap Gidding.
1917-21	Attended night classes in fine arts and gilding at Rotterdam Academy of Fine Arts and Techniques, possibly returning to finish his studies again in 1925.
1920	Left Gidding's firm to work for Bernard Romein, art director and designer for a Rotterdam department store.
1926	Immigrated illegally by ship to the United States, arriving August 15 in Newport News, Virginia, ultimately settling in Hoboken, New Jersey. Worked as a house painter.
1927	Moved to New York City.
1929-31	Met John Graham, Stuart Davis, David Smith, dealer Sidney Janis and Arshile Gorky who became one of his closet friends until Gorky's suicide in 1948.
1935	Joined mural division of WPA Federal Art Project; worked on mural for Williamsburg Federal Housing Project, Brooklyn (never executed). Left WPA after one year because he was not a U.S. citizen.
1936	Began painting full time. Included in first museum exhibition, *New Horizons in American Art*, Museum of Modern Art, New York, cat. Met critic Harold Rosenberg.
1937	Met art student Elaine Fried, who became his student. Commissioned to design one section of three-part mural, *Medicine*, for 1939 New York World's Fair, Hall of Pharmacy.
1942	Met Jackson Pollock.
1943	Married Elaine Fried.
1948	First solo exhibition, *de Kooning*, Charles Egan Gallery, New York. Met critic Thomas Hess. Taught at Black Mountain College, North Carolina. First museum purchase, *Painting*, 1948, by Museum of Modern Art, New York.
1949	Joined newly organized artists' discussion group, *The Club*, 39 East 8th Street, New York (was charter member).
1950	Completed *Excavation*, subsequently exhibited at XXV Venice Biennale, June 3–October 15. Began work on *Woman I*, 1950–1952.
1951-52	Began spending summers in East Hampton, New York.
1953	First retrospective exhibition, *de Kooning: 1935–1953*, School of the Museum of Fine Arts, Boston, Massachusetts, cat. Traveled to Workshop Art Center, Washington, D.C. Robert Rauschenburg requested and received drawing from de Kooning to erase, now known as *Erased de Kooning Drawing*.

1955	Separated from Elaine de Kooning.
1956	Daughter Johanna Liesbeth (Lisa) born to Joan Ward.
1957	Made earliest surviving print, an etching for Harold Rosenberg's poem, *Revenge*.
1958	Declined Museum of Modern Art's invitation to have major retrospective exhibition.
1959-60	Traveled to and painted in Rome.
1960	Traveled to and made first two lithographs in San Francisco.
1961	Began to build studio in Springs, New York.
1962	Became U.S. citizen.
1963	Moved permanently to Springs from New York City.
1964	Awarded the Presidential Medal of Freedom by President Lyndon B. Johnson.
1965	First American museum retrospective, *Willem de Kooning*, Smith College Museum of Art, Northampton, Massachusetts, cat. Traveled to The Hayden Gallery, Massachusetts Institute of Technology, Cambridge.
1968	Returned to the Netherlands for first time since 1926 for opening of his first solo exhibition at the Stedelijk Museum, Amsterdam, cat. in Dutch/ English, the first of five venues of the retrospective, *Willem de Kooning*, organized by Thomas B. Hess for the Museum of Modern Art, New York, cat. Traveled to The Tate Gallery, London; The Art Institute of Chicago; Los Angeles County Museum of Art.
1969	Traveled to Japan with Xavier Fourcade. Traveled to Spoleto and Rome. Modeled first 13 sculptures in clay which were then cast in bronze at the foundry of sculptor and friend, Herzl Emanuel.
1970-71	Created series of lithographs at Hollander Workshop, New York.
1975	First one-man exhibition at Fourcade, Droll Inc., New York (*De Kooning: New Works—Paintings and Sculpture*), cat. Xavier Fourcade, Inc. succeeded Fourcade, Droll in 1976 and represented de Kooning exclusively until Xavier Fourcade's death in April 1987.
1978	Resumed daily contact with Elaine de Kooning.
1979	On his 75th birthday, Dutch government made him an Officer of the Order of Orange-Nassau.
1980	Started work on mid-size and monumental enlargements of first of three 1969 bronzes, to be cast at Tallix Foundry, Peekskill, New York.
1983-84	Major retrospective exhibition, *Willem de Kooning: Drawings, Paintings, Sculpture*, Whitney Museum of

American Art, New York, cat. Traveled to Academie der Künste, Berlin, cat. in German; Musée National d'Art Moderne, Centre Georges Pompidou, Paris, cat. in French.

1989 Elaine de Kooning died. As de Kooning was not able to manage his business affairs, Lisa de Kooning and John L. Eastman petitioned the New York Supreme Court to become conservators of the property of Willem de Kooning. Lisa de Kooning and John L. Eastman appointed conservators of the property of Willem de Kooning.

1993 First comprehensive exhibition of largest public collection of his works, *Willem de Kooning from the Hirshhorn Museum Collection*, Hirshhorn Museum and Sculpture Garden, Washington, D.C., cat. Traveled to Fundació "la Caixa," Barcelona, cat. in Spanish; High Museum of Art, Atlanta, Georgia; Museum of Fine Arts, Boston, Massachusetts; Museum of Fine Arts, Houston, Texas.

1994 His 90th birthday. Paintings retrospective, *Willem de Kooning: Paintings*, National Gallery of Art, Washington, D.C., cat. Traveled to Metropolitan Museum of Art, New York; Tate Gallery, London.

1995 First museum overview of works from the 1980s, *Willem de Kooning: The Late Paintings, The 1980s*, San Francisco Museum of Modern Art, cat. Traveled to Walker Art Center, Minneapolis, Minnesota; Städtisches Kunstmuseum, Bonn, cat. in German; Museum Boymans-van Beuningen, Rotterdam; Museum of Modern Art, New York.

1997 Died at his home in East Hampton, New York, at the age of 92.

This chronology is based on the one compiled by Amy Schichtel, Collections Curator, the Willem de Kooning Revocable Trust, with excerpts from Diane Waldman's "Chronology," in *Willem de Kooning*. New York: Abrams, Inc., 1988, and from Judith Zilczer's "Chronology," in *Willem de Kooning from the Hirshhorn Museum Collection*. Washington, D.C.: Hirshhorn Museum and Sculpture Garden, 1993, (Spanish translation in Zilczer, Judith. *Willem de Kooning: Colleccio Hirshhorn Museum*. Barcelona: Centre Cultural de la Fundació "La Caixa," 1994.)

SELECTED CHRONOLOGY

1927	Born John Angus Chamberlain on April 16 in Rochester, Indiana, to Mary Francis Waller and Claude Chester Chamberlain.
1931	Moves to Chicago, Illinois; brought up by his maternal grandmother Edna Brown Waller.
1943	Leaves Chicago. En route to California, joins the U.S. Navy.
1943-46	Serves in the U.S. Navy aboard the aircraft carrier U.S.S. Tulagi; tours in the Pacific and Mediterranean.
1948	Moves to Detroit, Michigan. Marries Virginia Wooten.
1950	Studies hairdressing in Chicago through the Veterans Administration G.I. Bill.
1951-52	Attends the school of The Art Institute of Chicago.
1953-54	Works as a hairdresser and makeup artist in Chicago.
1955-56	Attends Black Mountain College in North Carolina; meets the poets Charles Olson, Robert Duncan and Robert Creeley.
1956	Moves to New York. Marries Elaine Grulkowski. Birth of first son, Angus Orion Chamberlain, in New York.
1957	First solo exhibition, at the Wells Street Gallery in Chicago. Makes *Shortstop*, his first sculpture made from auto-body parts, in Southampton, New York, at the home of Larry Rivers.
1958	First exhibition in New York, a two-man exhibition with Joseph Fiore at the Davida Gallery. Included in a group exhibition at the Hansa Gallery, New York. Birth of Jesse Claude Chamberlain, a second son, in New York.
1959	Maintains a studio at Tenth Street and Broadway in New York and lives in Rockland County, New York through 1961. Included in *Recent Sculpture USA* at The Museum of Modern Art, New York.
1960	First one-man exhibition in New York, at the Martha Jackson Gallery.
1962	Maintains a studio on Cherry Street, New York. Birth of third son, John Duncan Chamberlain, in New York. First one-man exhibition at the Leo Castelli Gallery, New York.
1963	Moves with his family to Embudo, New Mexico; begins his first series of auto-lacquer and metal-flake paintings. Spends the summer in Topanga Canyon, California.
1965	Returns to New York and maintains a studio at 53 Greene Street.

1966	Follows his family to Santa Fe, New Mexico; teaches graduate students at the University of New Mexico. Receives the John Simon Guggenheim Memorial Foundation Fellowship. Makes a series of fiberglass sculptures based on french-curve drawings. Spends the summer in Malibu, California; begins first instant sculptures, made of urethane foam.
1967	Returns to New York; shares a studio with Neil Williams at 60 Grand Street. Begins galvanized-steel sculptures.
1968	Makes his first film, *Wedding Night*, starring Ultra Violet and Taylor Mead, in New York, directed by John Chamberlain, and Buddy Wirtshafter, produced by John Chamberlain. *The Secret Life of Hernando Cortez*, a sixteen-millimeter, fifty-four minute color film starring Ultra Violet and Taylor Mead, made in Valladolla, Mexico, directed by John Chamberlain and produced by Alan Power. Travels to London to make *Wide Point*, a sixteen-millimeter, sixty-minute color film projected on seven screens simultaneously, starring Taylor Mead, directed by John Chamberlain and produced by Alan Power.
1969	Artist in residence at two corporations, in conjunction with the Art and Technology Program of the Los Angeles County Museum: first at Dart Industries, then, for two months, at the Rand Corporation. At Dart, proposes *SniFFter*, an olfactory stimulus-response environment consisting of one hundred bottled smells (adhesive tape, female skin in sun, downtown Las Vegas, wet fur, air at eleven thousand feet in New Mexico); the project is never fully developed. At Rand, a showing of *The Secret Life of Hernando Cortez* causes controversy and is banned; *The Rand Piece* is realized, a thirty-four page document of questions divided into two sections: What are the circumstances to these responses, and, What is the response to these circumstances? Visiting artist at the University of Wisconsin, Madison. Spends one month at the home of Lewis Manilow in Park Forest South, Illinois; makes a series of white and chrome sculptures. The *Penthouse* series of brown paperbag sculptures are made in a studio on Park Avenue South, New York.
1970	The Plexiglas pieces are begun in East Los Angeles and vacuum coated in Larry Bell's studio in Venice, California. Shares a studio with Neil Williams in Little Sycamore Canyon, California, where the *Morgansplit* paintings, a series of some twelve paintings intensely painted on an irregular surface, are made.
1971	Returns to New York and maintains a studio on Wooster Street. *John Chamberlain: A Retrospective Exhibition* opens at the Solomon R. Guggenheim Museum, New York.
1972	Lives and works at the ranch of Stanley Marsh III in Amarillo, Texas, where the group of works known as *The Texas Pieces* is begun. Makes a proposal to the Contemporary Arts Center in Cincinnati for the *Amarillo Piece*, an environment including projected images of a Panhandle feedlot from dawn to dusk, six urethane-foam couches regulated by the mean temperature of Amarillo, an audio of cows and wind, and odors of feedlot and cut hay; the project is never realized.
1973	Death of Elaine Chamberlain in Santa Fe, New Mexico.
1974	Moves to a studio at 67 Vestry Street in New York; resumes work with auto-body parts. Maintains this studio until 1980.
1975	*The Texas Pieces* exhibited at the Contemporary Arts Museum in Houston, outdoors at the Saint Louis Botanical Gardens, Missouri, and at the Minneapolis Museum of Fine Arts.

1977	Receives a second Guggenheim fellowship. Converts a barn in Essex, Connecticut, into a residence and outdoor studio. Begins taking photographs with a wide-lux camera. Marries Lorraine Belcher in New York.
1979	Receives a commission from the U.S. General Services Administration for the Federal Plaza in Detroit.
1980	Moves to Sarasota, Florida.
1981	Purchases and lives aboard the houseboat *Ottonello* at the marina in Sarasota where his yacht, the *Cocola*, is also moored. Establishes a studio at Tenth Street and Coconut in Sarasota and maintains an outdoor studio in Osprey, Florida, at the end of a junkyard; creates *Deliquescence* and hatches the inspiration for the first *Gondolas*.
1982	*Deliquescence* installed at the campus of Wayne State University in Detroit, Michigan. An extended exhibition of sculpture is presented by the Dia Art Foundation at the artist's former studio at 67 Vestry Street, New York, which is shown through 1985. *Chamberlain Gardens*, an outdoor exhibition of sculpture, is presented by the Dia Art Foundation at the artist's former residence in Essex, Connecticut, which is shown through 1984.
1983	An exhibition of his sculpture opens at the Art Museum of the Pecos in Marfa, Texas, sponsored by the Dia Art Foundation.
1984	Receives the Brandeis University Creative Arts award medal in sculpture. *John Chamberlain/Esculturas* exhibition opens at the Palacio Cristal, Parque del Retiro, Madrid. *American Tableau* is presented and installed at the Seagram Plaza in New York.
1985	Artist in Residence, Skowhegan School of Painting and Sculpture, Maine.
1986	Retrospective exhibition at the Museum of Contemporary Art, Los Angeles.
1987	Joins The Pace Gallery, New York. *Coloured Gates of Louisville: The Inevitable Return of The Indefatigable Dr. Fahey*, 1988, a wall relief, is commissioned by the Kentucky Center for the Performing Arts, Louisville.
1990	Elected a member of the American Academy and Institute of Arts and Letters, New York.
1991	Retrospective at the Staatliche Kunsthalle Baden-Baden, Baden-Baden, Germany and the Staatliche Kunstsammlungen Dresden, Dresden, Germany.
1993	Receives the 1993 Skowhegan Medal for Sculpture from the Skowhegan School of Painting and Sculpture, Skowhegan, Maine. Receives Lifetime Achievement Award in Contemporary Sculpture from the International Sculpture Center, Washington, D.C.
1997	Receives The National Arts Club Artists Award in New York January 16.
1999	Receives Distinction in Sculpture Honor from Sculpture Center in New York December 1.

This chronology is based on information from Julie Sylvester, *John Chamberlain: A Catalogue Raisonné*, New York 1986, pp. 226-228, supplementary information was added.

ACKNOWLEDGEMENTS

It is with gratitude that I acknowledge the generosity of the private lenders and the public institutions that have been willing to share their works, as well as the Willem de Kooning Revocable Trust, and John Chamberlain and Prudence Fairweather for their support. I would also like to thank Bernice Rose for writing the catalogue essay, Kirk Varnedoe, Marla Prather, Michael Govan and James Demetrion and the entire staff of PaceWildenstein.

–Arne Glimcher

Photography:

© Dan Budnik courtesy Woodfin Camp and Associates: p. 35

Gordon R. Christmas: plate 13

Geoffrey Clements / Photograph © 2001 Whitney Museum of American Art, New York: plate 4

Peter Foe/Fotoworks: plates 18, 19, 20

David Heald, The Solomon R. Guggenheim Museum: plate 1

Hester & Hardaway: plate 6

Bill Jacobson: plate 11, 17, 21

Tim Lee: plate 16

J.B. McCourtney: plate 9

© by Fred W. McDarrah: cover

Jimm Roberts: p. 19

Steven Sloan © 2001, NY / Photograph © 2001 Whitney Museum of American Art, New York: plate 5

Ellen Page Wilson: plates 7, 10, 14

Catalogue Design and Production by PaceWildenstein

Library of Congress Control Number: 2001095071

ISBN: 1-930743-09-2